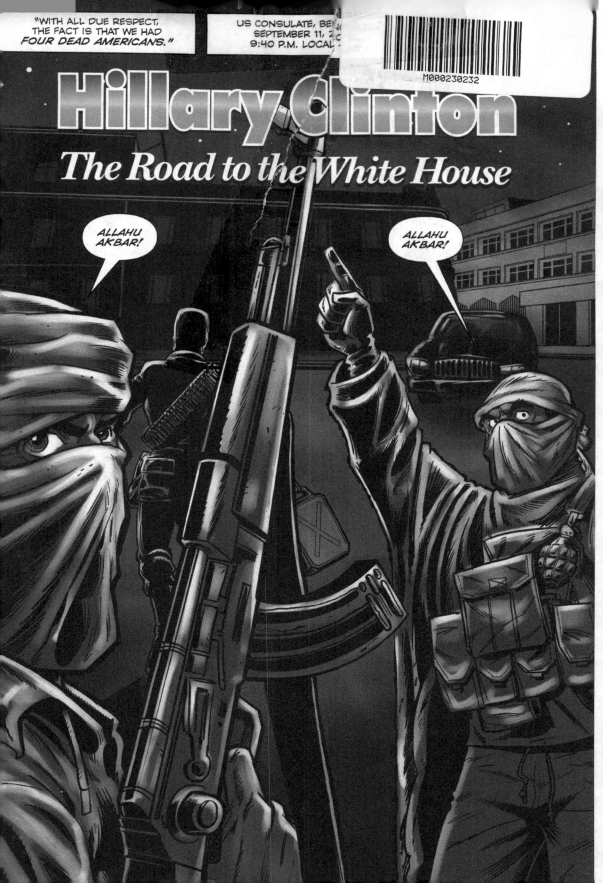

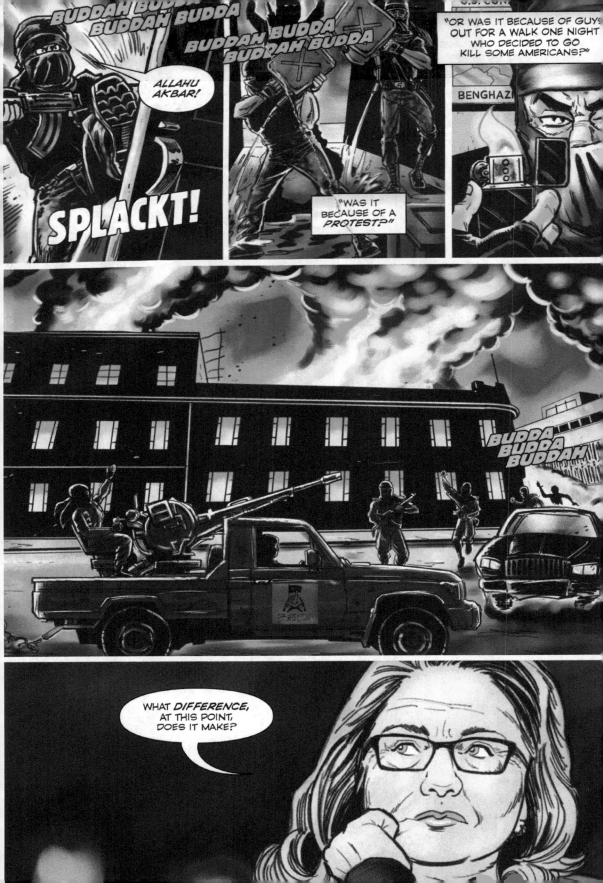

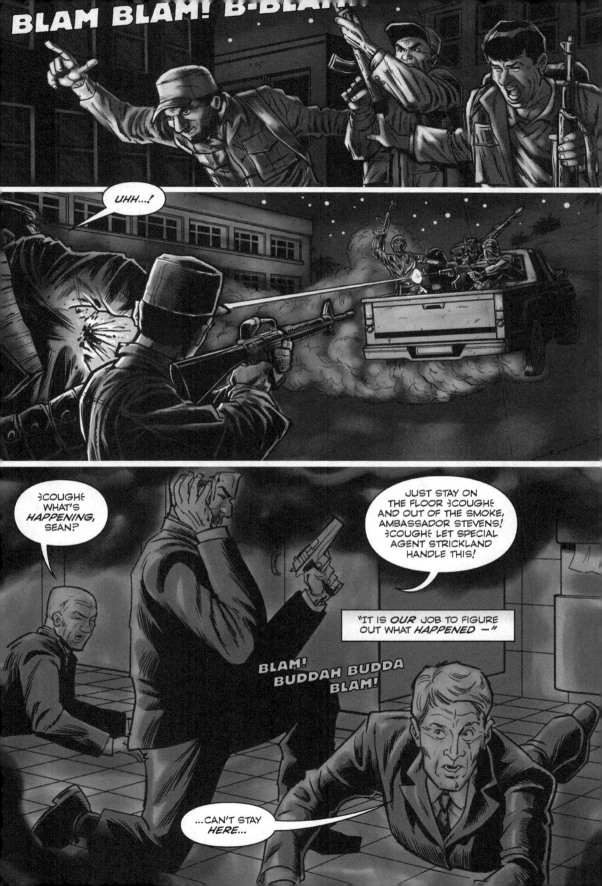

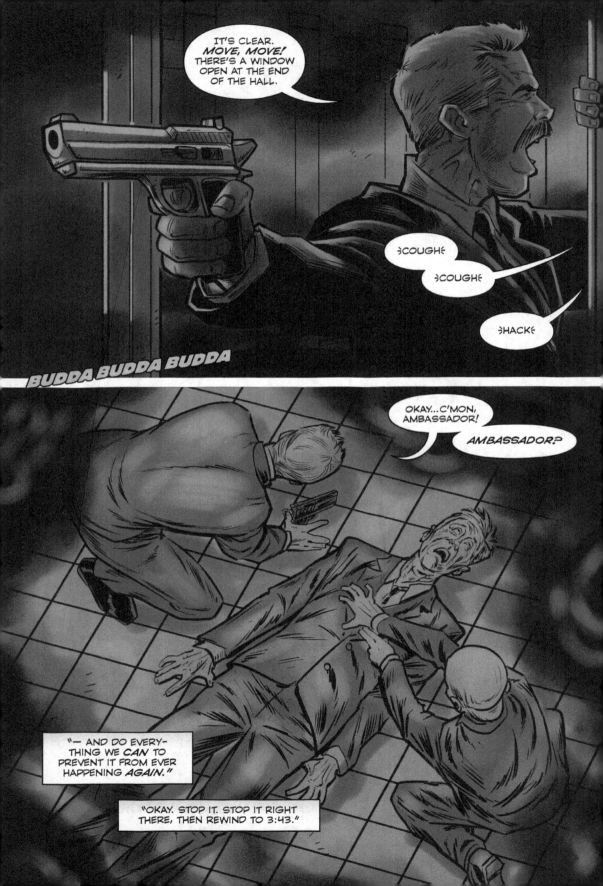

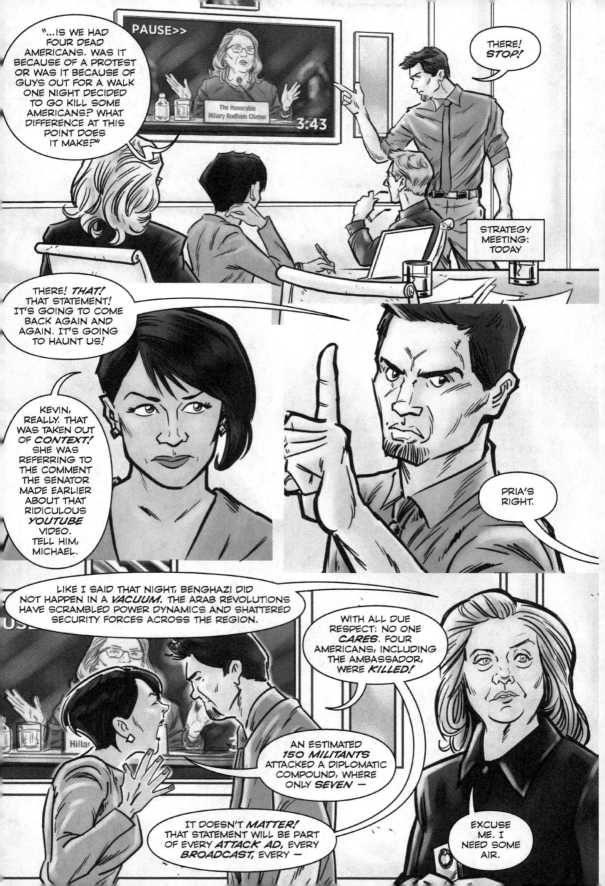

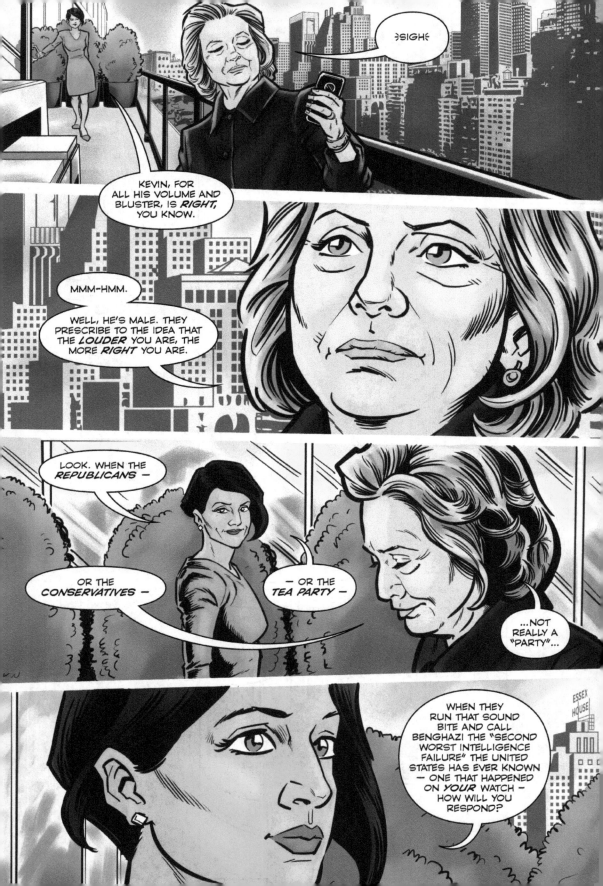

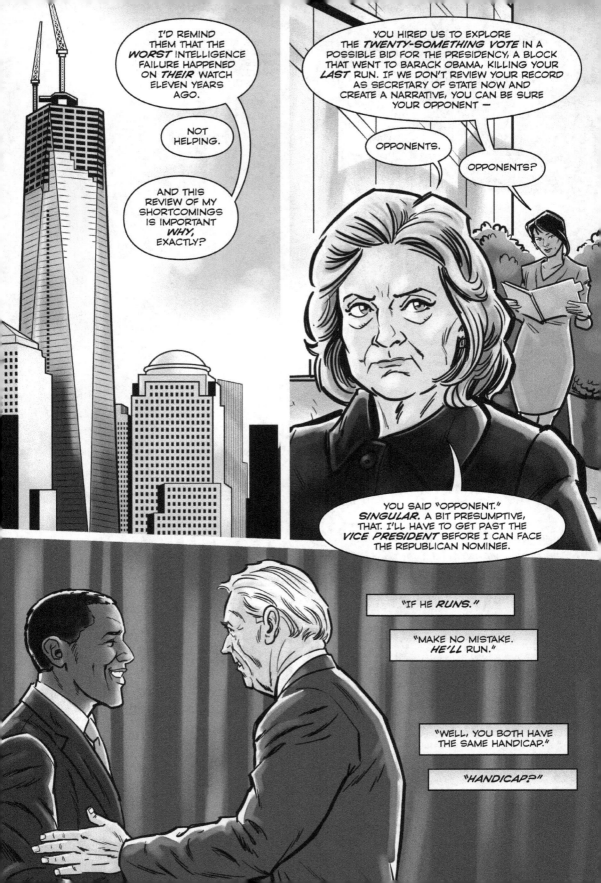

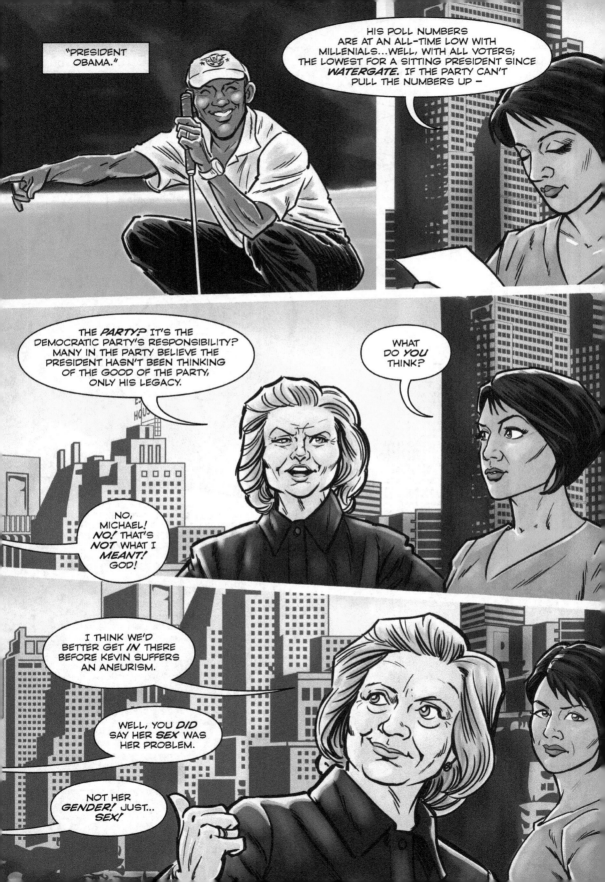

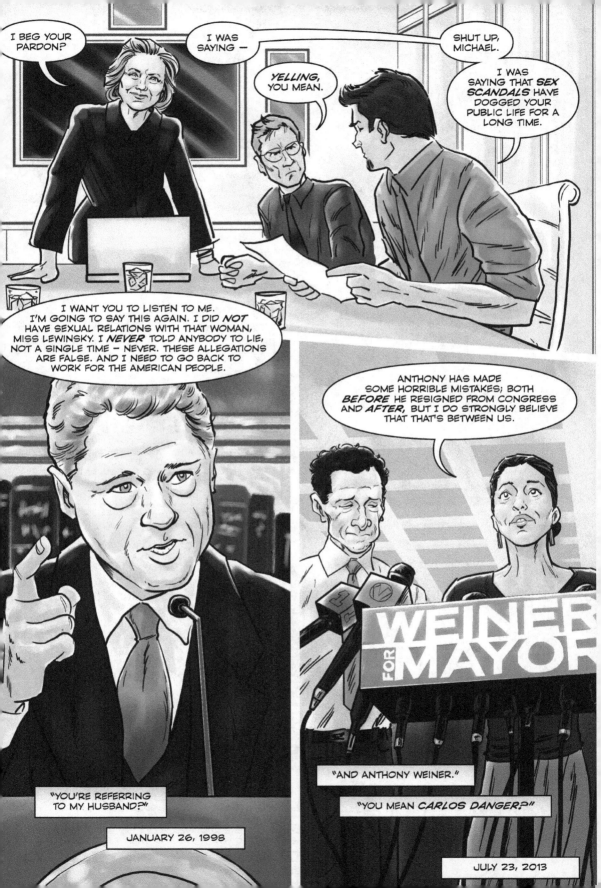

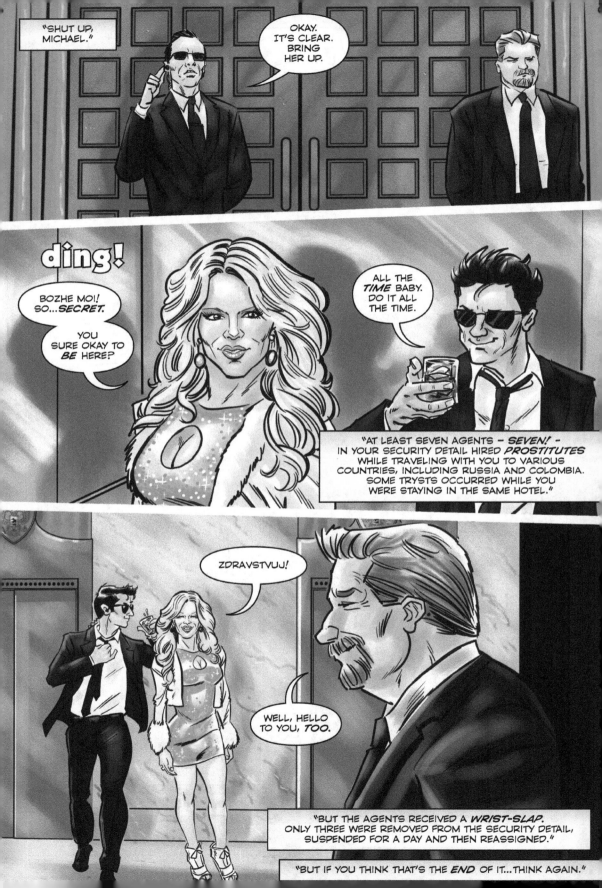

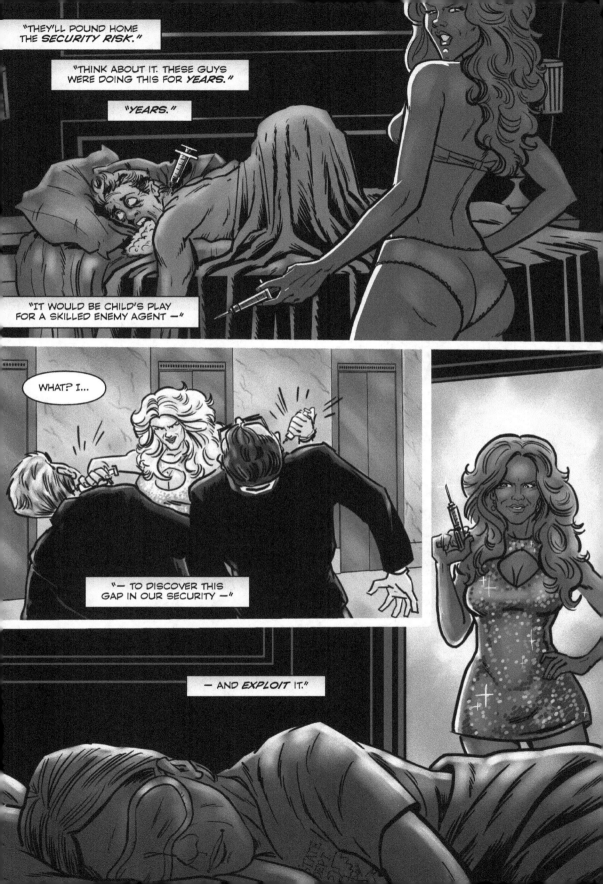

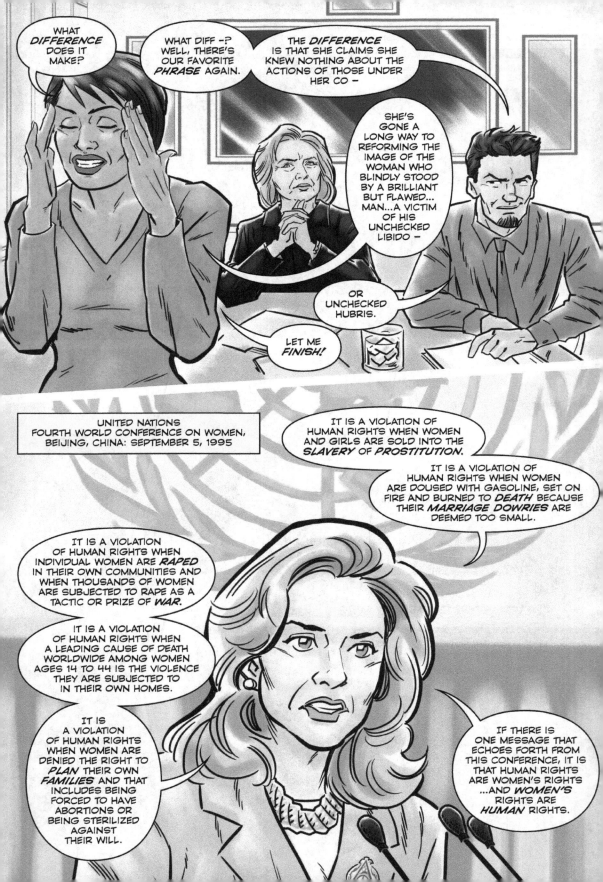

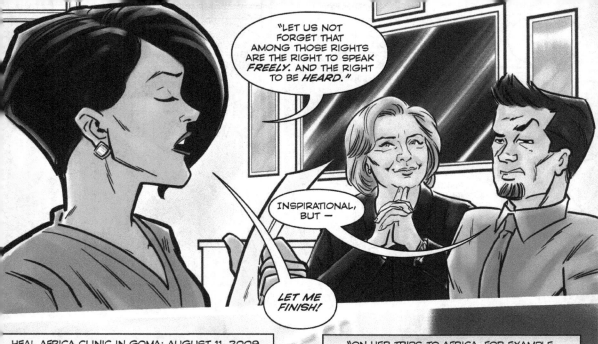

"LET US NOT FORGET THAT AMONG THOSE RIGHTS ARE THE RIGHT TO SPEAK *FREELY*. AND THE RIGHT TO BE *HEARD*."

INSPIRATIONAL, BUT —

LET ME FINISH!

HEAL AFRICA CLINIC IN GOMA: AUGUST 11, 2009

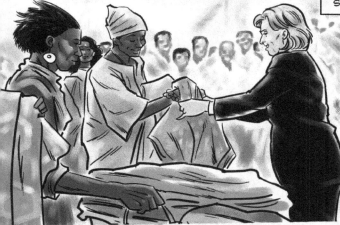

"ON HER TRIPS TO AFRICA, FOR EXAMPLE, SHE MET WITH WOMEN'S RIGHTS ACTIVISTS AND FARMERS *LONGER* THAN SHE MET WITH SOUTH AFRICA'S *PRESIDENT*, JACOB ZUMA."

"SHE TIRELESSLY POSITED WOMEN'S ROLES AND THEIR IMPORTANCE TO OUR FOREIGN POLICY, SO MUCH SO THAT PUNDITS ACTUALLY COMPLAINED THAT SHE WAS *CHEAPENING* THE ROLE OF SECRETARY OF STATE BY MEETING WITH SO MANY WOMEN!"

"THE *NEW YORK TIMES* CALLED HER A *ROCK STAR DIPLOMAT* AND CITED GOOGLE CHAIRMAN ERIC SCHMIDT, WHO CALLED HER THE MOST *SIGNIFICANT* SECRETARY OF STATE SINCE DEAN ACHESON."

"SHE LOGGED MORE FREQUENT-FLYER MILES THAN MOST SECRETARIES OF STATE."

"THE *TIMES* CLAIMS SHE RESTORED THE BATTERED MORALE OF THE OFFICE WHILE REMAINING RELATIVELY GAFFE FREE ON THE ROAD."

"ALL THIS WHILE SERVING A MAN WHO DEFEATED HER IN THE 2008 PRIMARIES!"

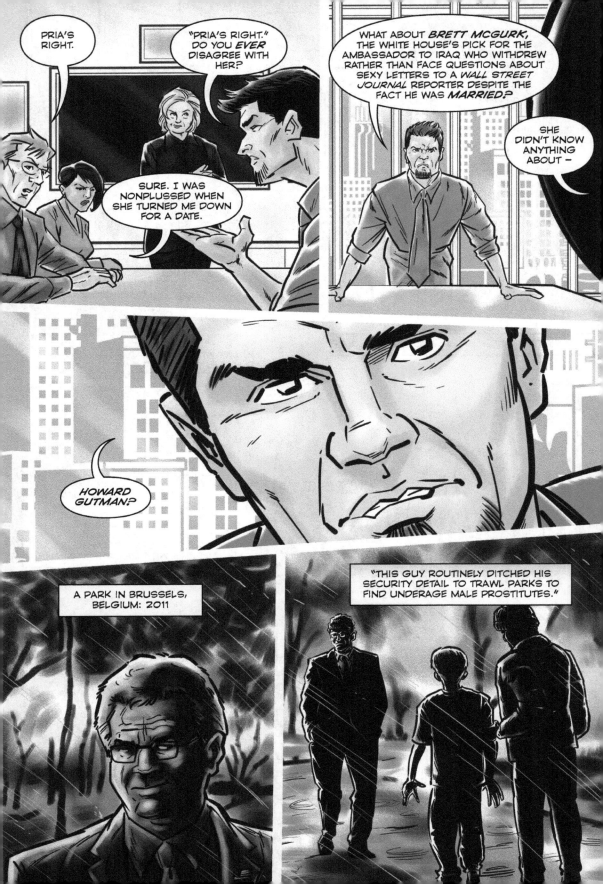

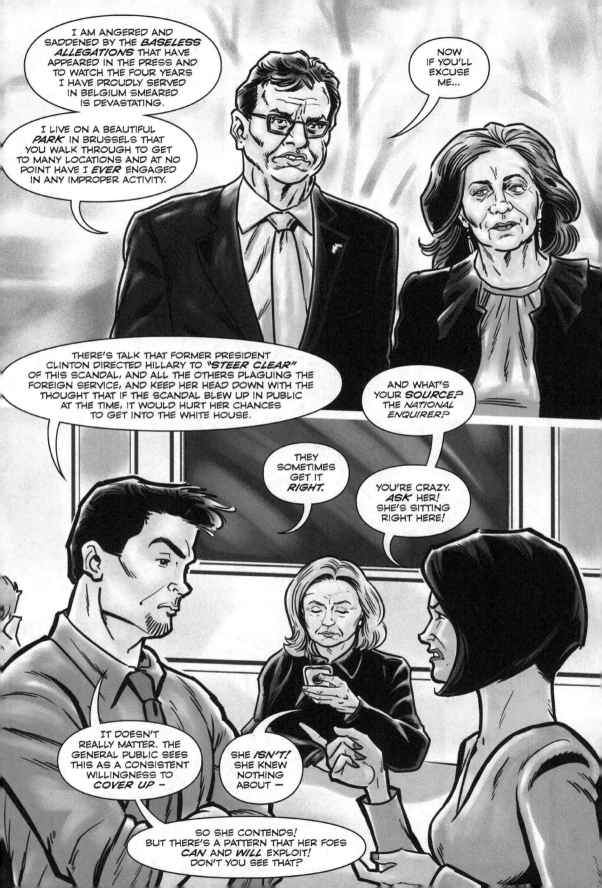

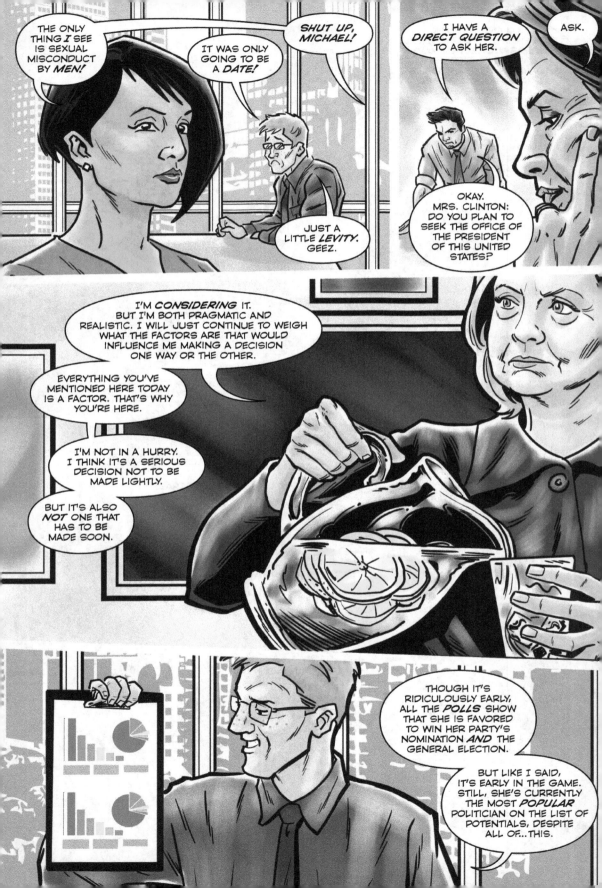

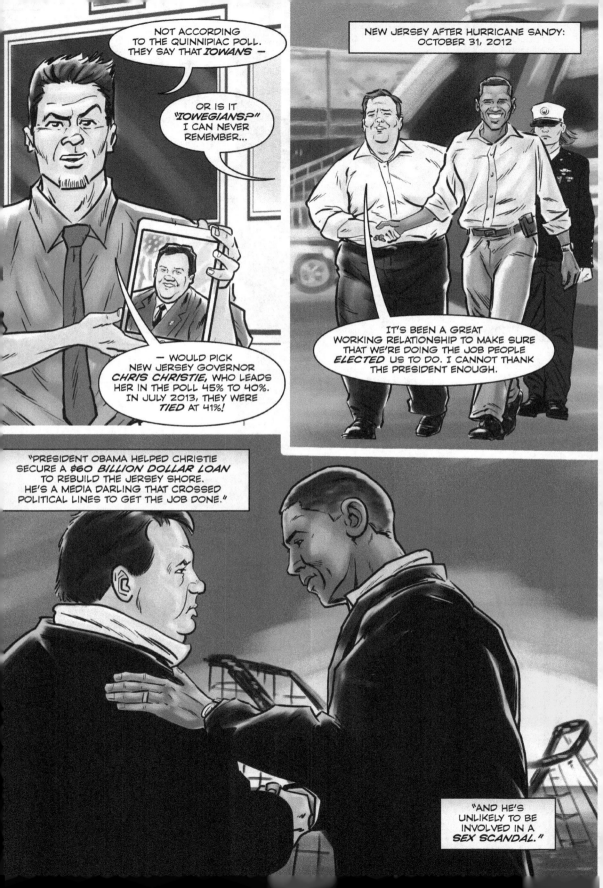

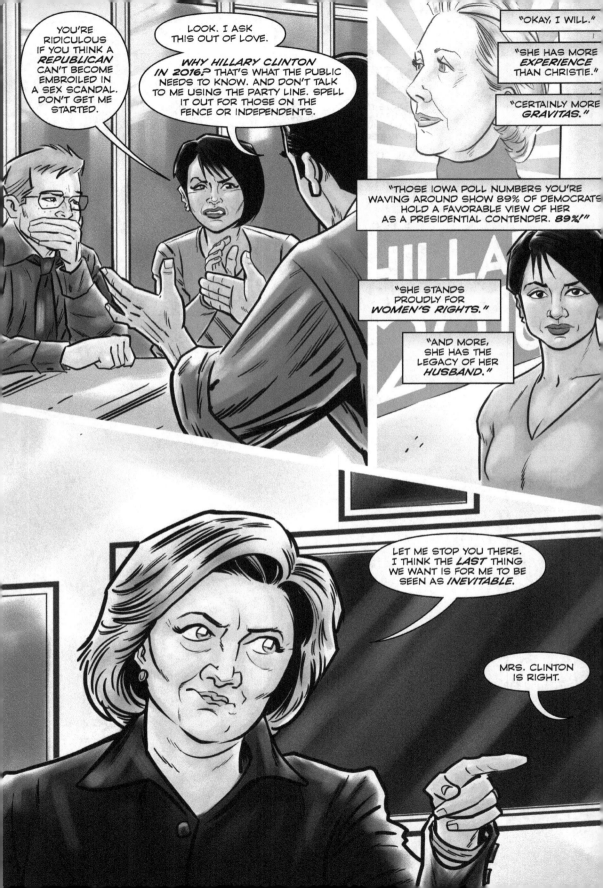

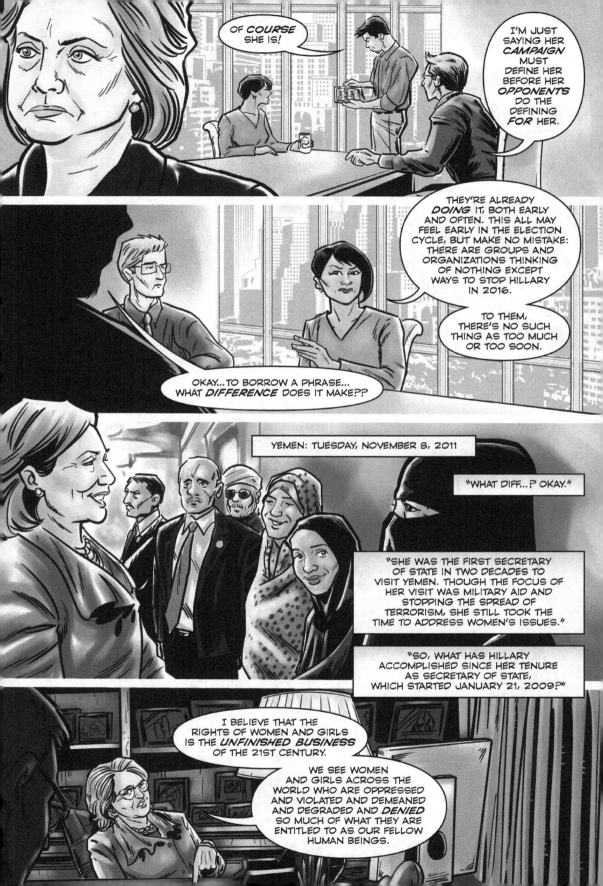

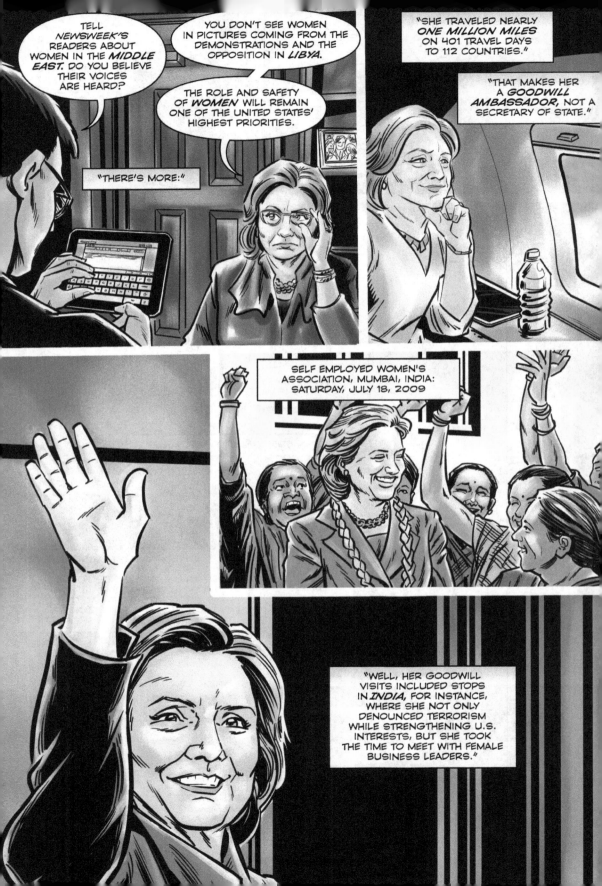

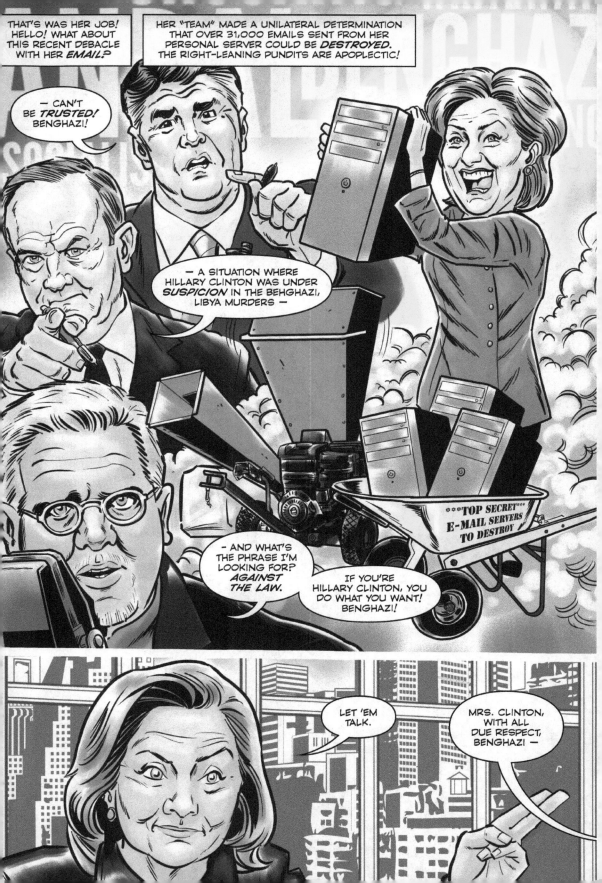

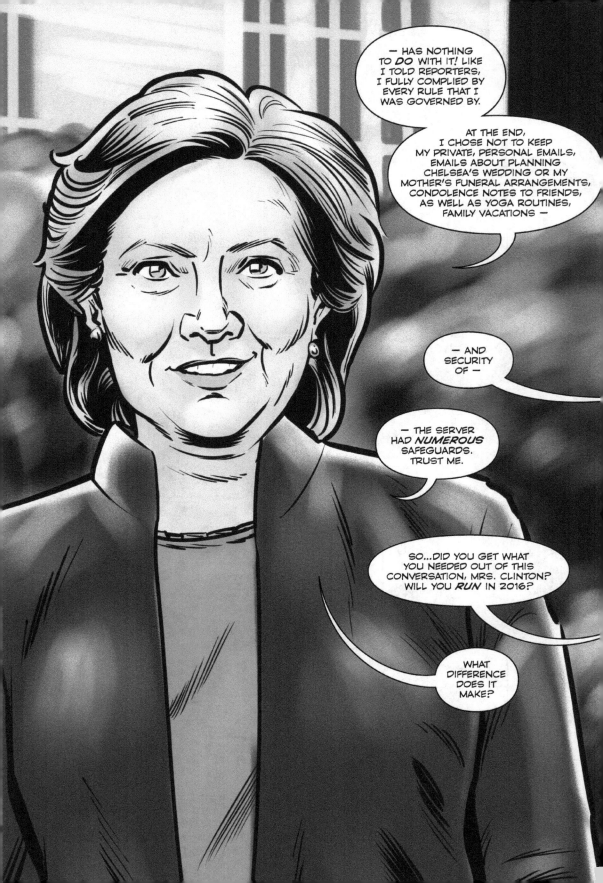

BLUEWATER COMICS

Michael L. Frizell — Writer

Joe Paradise — Penciler

Darren G. Davis — Editior

Gary Scott Beatty — Letterer

Joe Paradise — Cover

Darren G. Davis
Publisher

Maggie Jessup
Publicity

Scott Kaufman
Entertainment Manager

Susan Ferris
Entertainment Manager

www.bluewaterprod.com

#ERASEHATE WITH THE MATTHEW SHEPARD FOUNDATION

With your donated dollars and volunteer hours, we work tirelessly to erase hate from every corner of America through our programs.

SPEAKING ENGAGEMENTS

Since Matt's death in 1998, Judy and Dennis have been determined to prevent others from similar tragedies. By sharing their story, they are able to carry on Matt's legacy.

HATE CRIMES REPORTING

Our work to improve reporting includes conducting trainings for law enforcement agencies, building relationships between community leaders and law enforcement, and developing policy reform in reporting practices.

LARAMIE PROJECT

MSF offers support to productions of The Laramie Project, which depicts the events leading up to and after Matt's murder. It remains one of the most performed plays in America.

MATTHEW'S PLACE

MatthewsPlace.com is a blog designed to provide young LGBTQ+ people with an outlet for their voices. From finance to health to love and dating, and everything in between, our writers contribute excellent material.

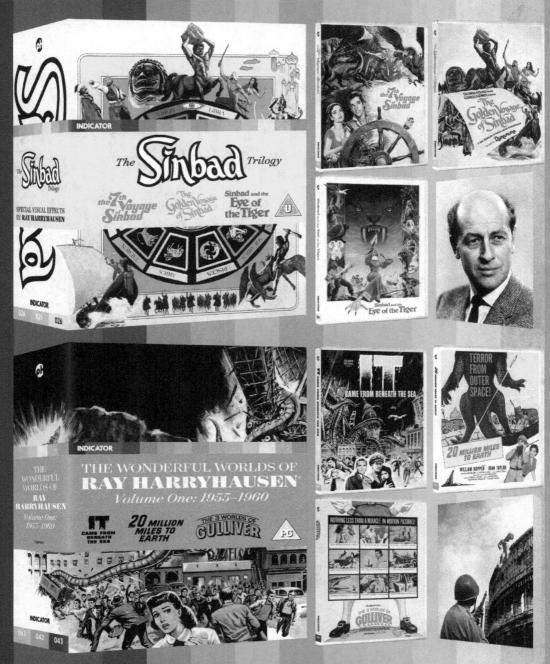

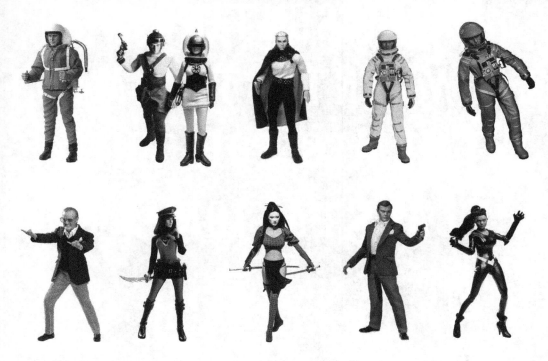

LICENSED & ORIGINAL DESIGNER COLLECTIBLES

CPSIA information can be obtained
at www.ICGtesting.com
Printed in the USA
BVHW090825150419
545534BV00017B/2176/P